Acrylic Painting
Step by Step

By Tom Swimm

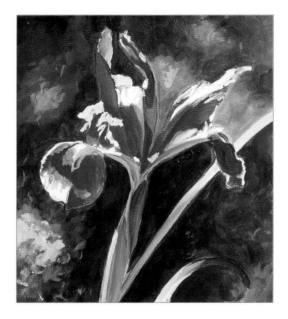

www.walterfoster.com

Contents

www.walterfoster.com
6 Orchard Road, Suite 100
Lake Forest, CA 92630

© 2005, 2012 Quarto Publishing Group USA Inc.
Published by Walter Foster Publishing,
a division of Quarto Publishing Group USA Inc.
Artwork © 2005, 2012 Tom Swimm.
All rights reserved. Walter Foster is a registered trademark.

Printed in China
5 7 9 10 8 6

Introduction

Since the late 1940s, interest in acrylic has gained popularity in an art world dominated by watercolor and oil paints. Acrylic paints can produce a wide range of painterly effects—from thin but vibrant washes to thick, impasto strokes. And this versatility has increased the demand for acrylic as a fine-art tool, delivering the medium from the realm of commercial art alone. But acrylic's versatility isn't the only reason for its growing popularity. This medium also holds a number of advantages over oil and watercolor; for example, it doesn't yellow or crack over time, and it doesn't bleed under protective varnishes. Acrylic does dry quickly, though, which allows painters to apply new layers of paint or rework underlying layers without muddying the colors. In addition, acrylic paints are relatively inexpensive when compared to oil paints, and they clean up easily with plain soap and water. For these reasons and more, acrylic is an ideal medium for beginners, as well as for artists interested in exploring and experimenting with a wide array of techniques.

In this book, I will demonstrate my own approach to painting in acrylic with 12 diverse step-by-step lessons, from an intimate doorway to a grand seascape. And, accompanying each lesson, you'll find all the information you need to follow along and re-create these beautiful scenes. I will also explain how to build realistic form and shape as I explore the fascinating contrasts between light and shadow. Plus I will provide plenty of inspiration for choosing your own subjects and creating your own masterpieces in acrylic!

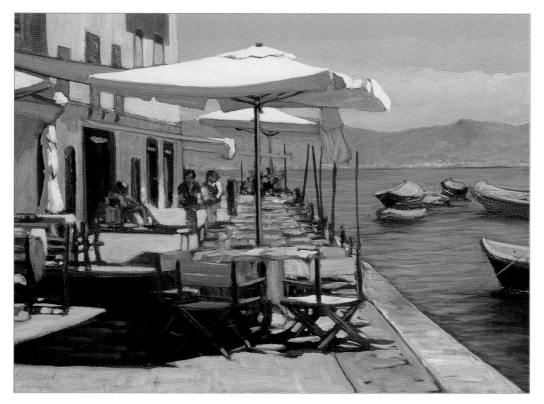

Tools and Materials

To get started with acrylic, you need only a few basic tools: paints, brushes, supports, and water. When you buy your acrylic supplies, remember to purchase the best you can afford, as better-quality materials are more manageable and produce longer-lasting works.

Paints

Acrylic paints come in jars, cans, and tubes. Most artists prefer tubes, as they make it easy to squeeze out the appropriate amount of paint onto your palette. There are two types of acrylic paints: "student grade" and "artist grade." Artist-grade paints contain more pigment and less filler, so they are more vibrant and produce richer mixes.

Brushes

Acrylic paintbrushes are categorized by hair type (soft or stiff; natural or synthetic), style (filbert, flat, or round), and size. For the projects in this book, I recommend small, medium, and large sizes of both sable (soft) and bristle (stiff) brushes. Synthetic-hair paintbrushes work well with acrylic, as the bristles are soft but springy enough to return to their original form. In addition to brushes, you'll also want to purchase a painting knife for mixing colors on your palette and experimenting with textural effects on your canvas.

Choosing Colors

A good beginner's palette of colors consists of one warm and one cool version of each of the primary colors: yellow, red, and blue. (For more about warm and cool colors, see "Exploring Color 'Temperature'" on page 6.) You'll also want to include white, black, and a few browns, such as burnt sienna or raw umber. From these basics, you should be able to mix just about any color you'll need. My basic palette consists of the 17 colors below.

Basic Palette From the top, left to right: alizarin crimson, burnt sienna, yellow ochre, Naples yellow, pink (or flesh), dioxazine purple, cadmium red light, cadmium yellow light, unbleached titanium, titanium white, sap green, emerald green, Prussian blue, phthalo blue, Payne's gray, light blue (or cerulean blue), and light blue-violet.

NOTE: *For the projects in this book, you'll also need the following colors: bright orange, brilliant blue, bronze yellow, cadmium orange, cadmium yellow medium, chromium oxide green, deep magenta, Indian red, light portrait pink, medium magenta, phthalo green, phthalo violet, raw sienna, and yellow oxide.*

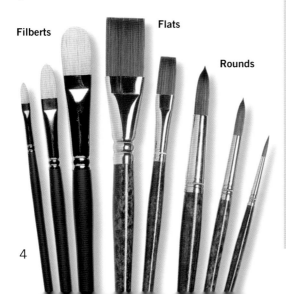

Filberts

Flats

Rounds

Creating a Studio

I have a very easy commute to my studio—it's located in my garage! With the garage door open, my workspace gets plenty of natural northern light. I also have an overhead array of track lighting so that I can work at night. Next to my easel, I have a multi-level taboret that keeps my tools close at hand. On the wall, I have pegboard for hanging works in progress as they dry.

Supports

Painting surfaces are also called "supports." Acrylic can be applied to almost any surface that has first been primed with gesso—a water-based mixture of a chalklike substance and glue that applies like paint and makes the surface less absorbent. This material also bonds well with the paint. Many artists choose to paint on primed canvases or canvas boards, which provide a fine-fabric surface with a slight grain. Primed pressed-wood panels offer a smoother alternative to canvas, as they have a fine-grained, less coarse surface. For the projects that call for a thin watercolor effect, you can use acid-free 140-lb. cold-press watercolor paper or canvas paper.

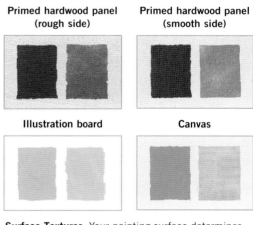

Primed hardwood panel (rough side) Primed hardwood panel (smooth side)

Illustration board Canvas

Surface Textures Your painting surface determines the textures of your strokes and washes. In the examples above, you can see how thick (left) and thin (right) applications of paint appear on the various supports.

Palettes

Palettes for acrylic paints are available in many different materials—from wood and ceramic to metal and glass. Plastic palettes are inexpensive, and they can be cleaned with soap and water. Disposable paper palette pads are also very convenient; instead of washing away the remains of your paint, you can simply tear off the top sheet to reveal a fresh surface beneath.

Other Materials

To get started, you'll need two jars of water: one for adding to your paint mixes and one for rinsing out your brushes. A spray bottle will help keep the paints and mixes on your palette moist, and paper towels or rags will help with cleanup. I also like to use a permanent (waterproof) felt-tip marker for sketching onto my canvas.

Color Theory and Mixing

Before you begin painting, it's important to know basic color theory. Color plays a huge role in the overall mood or "feel" of a painting, as colors and combinations of colors have the power to elicit various emotions from the viewer. On these pages, you'll learn some of the basic color terms referred to throughout the lessons in this book. You'll also discover how colors affect one another, which will help you make successful color choices in your own paintings.

Learning the Basics

The color wheel is a circular spectrum of colors that demonstrates color relationships. Yellow, red, and blue are the three main colors of the wheel; called *primary* colors, they are the basis for all other colors on the wheel. When two primary colors are combined, they produce a *secondary* color (green, orange, or purple). And when a secondary and primary color are mixed, they produce a *tertiary* color (such as blue-green or red-orange). Colors that lie directly opposite one another on the wheel are called "complements," and groups of colors that are adjacent on the color wheel are referred to as "analogous."

Warm yellow Cool yellow

Secondary: Orange

Secondary: Green

Warm red

Tertiary: Blue-green

Cool red

Cool blue

Warm blue

Secondary: Purple

The Color Wheel This handy color reference makes it easy to spot complementary and analogous colors, making it a useful visual aid when creating color schemes.

Exploring Color "Temperature"

The colors on the color wheel are divided into two categories: *warm* (reds, oranges, and yellows) and *cool* (blues, greens, and purples). Warm colors tend to pop forward in a painting, making them good for rendering objects in the foreground; cool colors tend to recede, making them best for distant objects. Warm colors convey excitement and energy, and cool colors are considered soothing and calm. Color temperature also communicates time of day or season: warm corresponds with afternoons and summer, and cool conveys winter and early mornings.

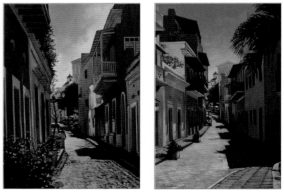

Seeing the Difference in Temperature Above are two similar scenes—one painted with a warm palette (left), and one painted with a cool palette (right). The subtle difference in temperature changes the mood: The scene at left is lively and upbeat; at right, the mood is peaceful.

Using Color Complements

Selecting your palette based on a pair of complementary colors can add a vibrancy to a painting that's difficult to attain with other color combinations. When placed next to each other, complementary colors (such as green and red) make one another appear brighter and dynamic because they seem to vibrate visually.

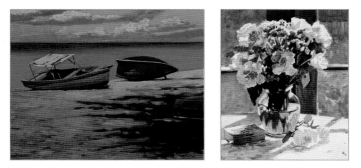

Applying Complementary Color Schemes The paintings above demonstrate two different complementary color schemes. The boat image (left) utilizes a blue and orange scheme that makes the sand appear to glow beneath the sun. The vase and roses (right) have a yellow and purple color scheme, causing the flowers to radiate with intensity—even in the soft light from the window.

Mixing Neutrals

Neutral colors (browns and grays) are formed either by mixing two complementary colors or by mixing the three primaries together. By altering the quantity of each color in your mix or by using different shades of primaries, you can create a wide range of neutrals for your palette. These slightly muted colors are more subtle than those straight from the tube, making them closer to colors found in natural landscapes. Below are a few possibilities for neutral mixes using the colors of a basic palette.

Prussian blue + alizarin crimson + Naples yellow

Phthalo blue + cadmium red light + cadmium yellow light

Light blue-violet + burnt sienna + yellow ochre

Understanding Value

Value is the lightness or darkness of a color or of black, and values are used to create the illusion of depth and form in two-dimensional artwork. With acrylic paints, artists generally lighten paint mixes with lighter paint, such as white or Naples yellow. However, acrylic can also be applied in thin washes like watercolor, in which case the white of the paper beneath the paint acts as the lightener. Creating a value scale like the one below will help you determine how the lightness or darkness of a color is altered by the amount of water added.

Value Scale Creating value scales like the ones above will help you get a feel for the range of lights and darks you can create with washes of color. Apply pure pigment at the left; then gradually add more water for successively lighter values.

Acrylic Techniques

There are an endless number of ways to apply and manipulate acrylic paint. The next four pages share some of the most common techniques and special effects—from drybrushing to spattering. Once you get the basics down, you'll be able to decide which techniques work best for each of your subjects. And remember that, as you paint, it's a good idea to get in the habit of spicing up your art with multiple techniques, which will help keep your painting process from becoming too repetitive or formulaic.

Flat Wash A wash is a thin mixture of paint that has been diluted with water. The most common type of wash—a flat wash—is used to quickly cover large areas of a canvas with solid color. First load a large flat brush with your mix of paint and water; then tilt the paper as you lightly sweep overlapping, horizontal strokes across the page. Gravity will help pull and blend the strokes together.

Graded Wash With a graded wash, the color transitions down the page from dark to light, creating a gradation that's perfect for skies or water. Tilt the canvas and paint horizontal strokes across the top in the same manner as for a flat wash. But this time, add more water to your mix with each successive stroke of the brush. The color will gradually fade out as you move down the painting.

Wet-into-Wet For this technique, apply a color next to another that is still wet. Blend the colors by stroking them together where they meet, and use your brush to soften the edges to produce smooth transitions. This technique is ideal for painting sunset skies, where subtle blends and gradations are used to suggest depth.

Thick on Thin To produce color variances that have texture, apply a thin wash of color for the base and then paint thickly on top. Allow some of the underpainting to show through in places; this will create visible strokes, producing a texture perfect for rendering rough or worn painted surfaces, such as old buildings or walls.

Drybrushing To create coarse, irregular strokes, load your brush and wipe off excess paint with a paper towel; then lightly drag the brush over the support. This is good for creating rough, natural textures, like wood.

Dabbing For soft dabs of built-up color, load the tips of your brushes with paint and dot on color in a jabbing motion. Layering several different shades of green and yellow will give fullness and dimension to foliage.

Sponging To produce a mottled texture, use a sponge to apply the paint. First dab the sponge in the paint; then lightly dab your canvas. The resulting texture is perfect for rendering sand, rocks, or clouds.

Scraping Also called *sgraffito,* scraping removes wet paint from the canvas to reveal lighter values beneath. Use a pointed tool or your brush handle to "draw" lines in the paint, such as those for the veins of leaves.

Spattering Speckle your canvas with fine dots of color with this technique. Just load your paintbrush with diluted paint and run your thumb against your brush's bristles. This can be used for depicting flower fields or to produce a grainy texture.

Impasto To create a buttery texture, apply very thick strokes of paint to your canvas with either your paintbrush or your palette knife. This adds dimension to the paint itself, making it perfect for rendering the foamy white crests of waves.

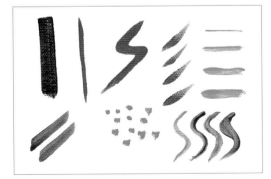

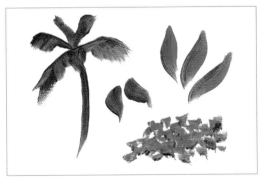

Drawing with the Brush Use the round tip of your brush to produce long, thin lines, or use a flat brush to produce thicker lines. "Drawing" with the paint makes it easy to add crisp edges and small details to your paintings, such as flowers, leaves, and stems.

Double-Loading the Brush For this technique, dip a loaded brush into a second color. As you stroke, both colors will appear side by side. This technique produces interesting, two-toned shapes that are perfect for rendering leaves, flower petals, or distant trees.

Glazing

Glazes are thin mixes of paint and water or acrylic medium (see below) applied over a layer of existing dry color. An important technique in acrylic painting, glazing can be used to darken, lighten, or change the hue of areas of a painting. Glazes are transparent, so the previous color shows through to create rich blends. They can be used to accent or mute the base color, add the appearance of sunlight or mist, or even alter the perceived color temperature of the painting.

When you start glazing, create a mix of about 15-parts water and 1-part paint. It's better to begin with glazes that are too weak than ones that are too overpowering, as you can always add more glazes after the paint dries.

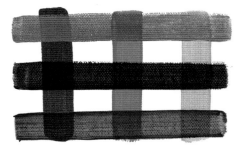

Glazing Grid These glazes (secondary colors orange, green, and purple) affect the appearance of the underlying colors (primaries red, blue, and yellow), and the colors blend visually where they overlap.

Experimenting with Mediums

There are a variety of acrylic mediums available that let you change the consistency of the paint. Some increase the flow of the paint, some act as a varnish, and some affect the paint's drying time. As you gain experience with the various mediums, you'll soon be able to choose the one that's appropriate for your painting subject. The three mediums used in this book are shown below, but it's important to know the other options that are available.

• **Matte medium** thins the paint and creates a soft satin sheen when dry.
• **Texture medium** thickens the paint to a moldable paste capable of creating ridges and patterns.
• **Retarding medium** slows the drying speed of the paint, allowing you time to produce soft blends.
• **Flow improver medium** helps the paint flow easily and is a safe alternative to diluting it with water, which can break up the pigments.

Gloss medium thins the paint and gives it a shiny, lustrous finish when dry.

Glazing medium thins the paint and helps to achieve vibrant glazes.

Gel medium adds body to the paint without affecting the final color of the dried paint.

Applying an Underpainting

An *underpainting* is a wash or combination of washes applied to the canvas at the beginning of the painting process. An underpainting can be used to simply tone the support with a wash of color to help maintain the desired temperature (cool or warm) of your final painting (see pages 12–15), or it can be used as a base color that will "marry with" subsequent colors to create a unified color scheme. You can also use an underpainting to create a visual color and value "map," giving you a guideline for applying future layers. No matter what you intend with an underpainting, it will give your paintings harmony and depth. I generally use a wash of magenta, burnt sienna, purple, or phthalo violet to prepare the canvas surface for painting. These colors work best with my palette of colors, as they have a luminous quality that shows through the layers to produce warm light.

Magenta

Burnt sienna

Purple

Phthalo violet

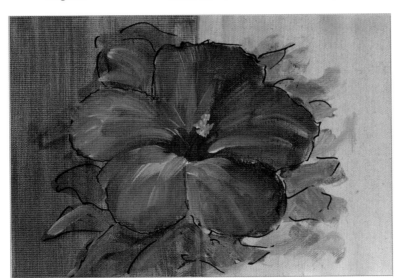

Underpainting for Temperature In the example at left, the flower has been painted over two different underpaintings: magenta (left) and light blue (right). Although I've used the same colors to render the final flower, the underpainting color greatly affects the later layers. Notice that the left half of the flower is significantly warmer in temperature, whereas the right half has a cool blue undertone.

Using Frisket

Frisket is a material used to preserve the white of your paper as you paint. Applying frisket over the areas you want to remain white allows you to paint freely because the frisket will resist subsequent layers of paint. When you're done painting, you can rub it off with your finger or an eraser.

Types of Frisket Liquid frisket, or masking fluid, is a latex-based substance that you can apply with an old paintbrush. Paper frisket is a clear adhesive that you can cut to fit the area you want to protect from paint.

Beginning with an Underpainting

When you want to produce a painting with a particular mood, remember that the first applications of acrylic paint will influence the "temperature" and feeling of the completed painting. So begin by applying a warm or cool base coat to the canvas before defining any ob-jects in the composition. Unless applied extremely thickly, acrylic paint is not an opaque medium. Therefore this base coat—or *underpainting*—will show through and interact with the subsequent layers of paint, unifying the painting with an even sense of temperature. For the bright, sun-drenched shore in this painting, I choose a warm, medium magenta for the underpainting—a rich color that glows through even the final layers of the painting, resulting in a warm, tropical feel.

Color Palette
burnt sienna, cadmium red light, cadmium yellow medium, dioxazine purple, flesh, light blue, light blue-violet, medium magenta, Naples yellow, Payne's gray, phthalo blue, phthalo green, raw sienna, titanium white, unbleached titanium, and yellow ochre

Step One First I work out my sketch, using both a pencil and a permanent marker to make a rough drawing. I define the basic shapes of the boats, as well as the outline of the clouds and the shadows on the beach. Then I use a large brush and cover the surface with a warm, water-thinned, transparent layer of medium magenta.

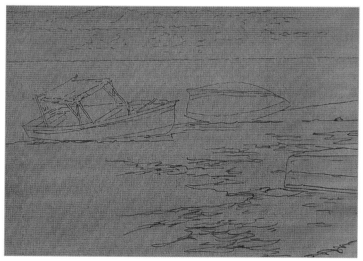

WATER
Phthalo blue +
light blue-violet

CLOUD SHADOWS
Magenta +
light blue-violet

TREE SHADOWS
Dioxazine purple +
burnt sienna +
Payne's gray

CLOUD HIGHLIGHTS
Naples yellow + white

Step Two I begin blocking in color using a large flat brush and paint thinned with acrylic gloss medium and water. I apply light blue mixed with phthalo blue for the sky and water, using raw sienna for the boats and beach. I also add a little of the blue mix to the inside of the boat on the left to represent reflected light. And I define the shadow areas using Payne's gray for the underside of the clouds and dioxazine purple for the shadows in the foreground and on the boats.

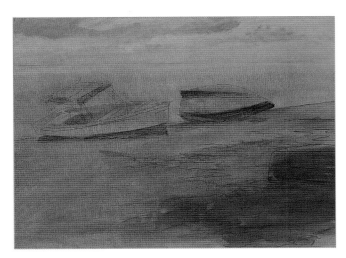

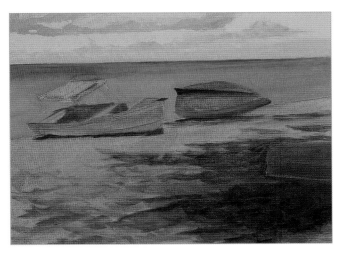

Step Three I apply color more thickly at this stage, using light blue for the sky between the clouds and phthalo blue for the water. I also paint around the hulls of the boats, adding dioxazine purple and Payne's gray to the shadows. Then I darken the shadows with burnt sienna, and I add a layer of raw sienna to the boats and the beach. Finally I add details to the foreground boat, using light blue-violet mixed with Payne's gray for the hull and burnt sienna for the stripe.

Step Four Now I darken the under-side of the clouds using Payne's gray mixed with light blue-violet. I mix phthalo blue, phthalo green, and white with an acrylic gloss medium to keep the paint wet and help it blend smoothly; then I apply a graded wash (see page 8) to the water with a medium flat sable brush, starting at the horizon line. I also apply this mix inside the boat on the left. Next I add another layer of color to the boat hulls and the beach, using the same mixes from step two.

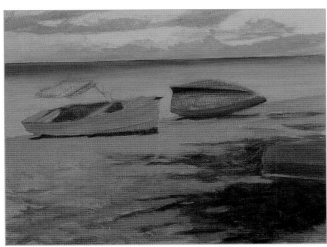

13

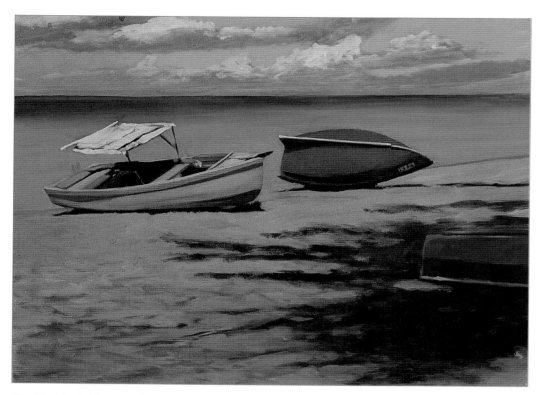

Step Five I paint the tops of the clouds, boat canopy, and hull highlights with a thick mix of unbleached titanium, Naples yellow, and flesh. Then I define the shadows with a grayish brown mix of dioxazine purple, Payne's gray, and burnt sienna, and I define the edges and seats with light blue. For the hull of the boat at right, I apply a mix of cadmium red, burnt sienna, and raw sienna; for the boat hull at left, I apply a mix of cadmium red light and yellow ochre. Next I brighten the highlights with a mix of cadmium yellow medium and cadmium red light. For the boat on the right, I mix cadmium red light with burnt sienna for the hull, also adding a few accents to the underside. Finally I drybrush darker shadows in the foreground and apply highlights using Payne's gray mixed with light blue-violet.

Boat Detail To add highlights, I drybrush a few strokes of unbleached titanium. As I brush lightly over the grain of the canvas, the bristles create a coarse, wood texture that mimics the surface of the boat.

Clouds Detail I highlight the clouds with a light mix of Naples yellow and white. I squiggle a few areas of color over the lightest parts of the clouds to show where the sunlight hits them most strongly.

Shadow Detail To create greater contrast between the sunlit and shadowed areas of sand, I drybrush a dark brown mix for the shadows and highlight the holes with a mix of cadmium yellow medium, raw sienna, and white. This shadow pattern—created by an overhanging tree outside the composition—adds interest and leads the eye toward the two boats.

Canopy Detail Painting an object white doesn't mean applying only white paint. White subjects can be colorful because they reflect surrounding colors. I let the underpainting show through the strokes. I add light yellow highlights with a mix of white, Naples yellow, and unbleached titanium, and I tint the shadows with raw sienna.

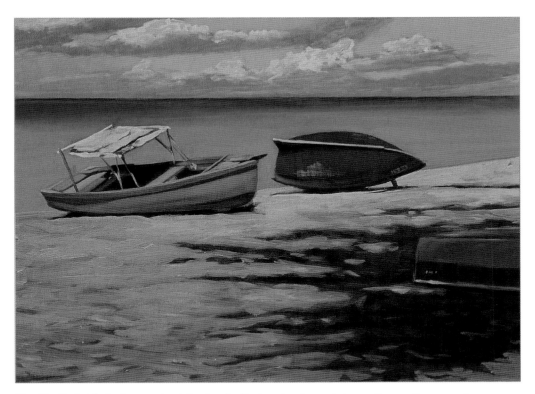

Step Six To finish, I mix several paint colors for the beach using cadmium yellow medium, raw sienna, Naples yellow, flesh, and white. To add contrast and interest in this area, I create several mixes, using varying proportions of each color. With a large flat sable brush and a thicker mix of these colors, I apply highlights on the beach, varying the direction of the brushstrokes. I continue to build up the colors overall, finishing with the final details to the clouds, boat hull, and support posts. I also finish the far boat by drybrushing a few strokes for the highlight.

Focusing on a Single Subject

The subjects of your paintings don't always have to be grand landscapes or carefully assembled still lifes. By zooming in on one object, you can often create an appealing composition that gives the viewer a sense of intimacy with the subject. And flowers are an ideal subject for a simple, close-up composition; their bright colors and delicate curves can fill your canvas with richness and interesting shapes. You can also heighten the drama by focusing on the foreground blossoms, contrasting their vibrant hues and crisp edges with a neutral, less detailed background, as I do in this painting of a simple iris bloom.

Color Palette
bronze yellow, cadmium red light, cadmium yellow light, chromium oxide green, dioxazine purple, medium magenta, Payne's gray, phthalo green, raw sienna, sap green, and titanium white

Step One Using a photograph as a reference, I create a fairly detailed pencil drawing of the iris. I choose pencil over waterproof ink because I intend to paint translucently. I am also careful to outline the areas of the lightest highlights because I will be "saving" these white areas from paint. After attaching my paper to a drawing board with masking tape to keep it flat, I paint the outlined highlight areas with liquid frisket. (See page 11.)

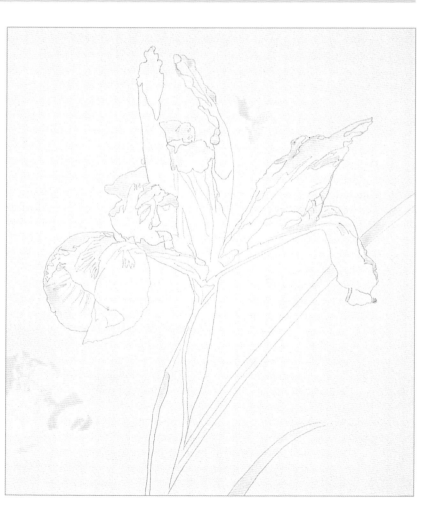

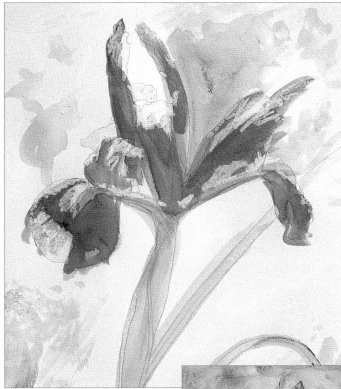

Step Two As I will be using my acrylic paints thinly, like watercolor paints, I begin by applying the lightest color first; in this case, I apply a light wash of raw sienna. Using a large flat brush, I thin the paint with water and apply it in quick, wet strokes. I use the edge of the brush to work around the drawing, but I'm not too concerned with "staying inside the lines"; I can always tighten the outlines at a later stage if they are too unwieldy. Ultimately I want to achieve a loose, free feeling. Next I apply thinned dioxazine purple to the iris petals in the same manner, varying the color intensity to add a sense of dimension.

Step Three I continue to apply the paint thinly, giving these beginning stages a "watercolor feel." I add sap green to the background, stroking roughly without worrying about the details or about perfect edges. At this point, the painting looks a bit messy—but, believe it or not, the hardest work is done. Now that the basic colors have been established, I can bring the iris to life with thicker, richer layers of paint.

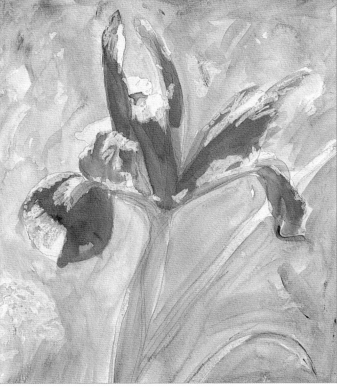

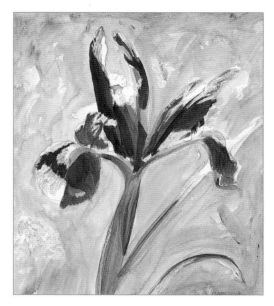

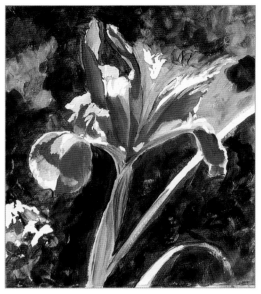

Step Four I use the edge of a medium flat sable brush to define the edges of the flower and the stem, adding acrylic gel medium to the paint to give it opacity. I clarify the lights and shadows of the petals by applying various values of dioxazine purple, thinning the paint with gloss medium for the lighter areas. For the stem, I mix sap green with raw sienna and a little Payne's gray. At this stage, my brushstrokes are more refined and deliberate, but I'm careful not to overwork any area. Then I apply dioxazine purple to the petals.

Step Five I add the dark background color followed by the highlights, applying neutral colors muted with cool glazes and quick, blurred brushstrokes. In contrast, the detail and brighter colors of the flower will command more attention. When the paint dries, I remove the frisket with rubber cement pickup, revealing the white, untouched canvas. Then I darken the background with a glaze of Payne's gray and acrylic gel medium. I add a thin layer of medium magenta to the tops and undersides of the petals.

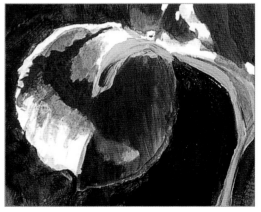

Background Detail I apply thick strokes of dioxazine purple, chromium oxide green, sap green, and bronze yellow to the background. Because it is meant to be abstract and out of focus, I apply paint randomly with strokes of varying thicknesses and in multiple directions.

Petal Detail I mix yellow ochre with cadmium yellow light and apply a swoop to the interior of the flower petals, following the curvature of their form. Then I load a small brush with cadmium red light and stroke from the center of the leaf toward the base, gradually lifting the brush.

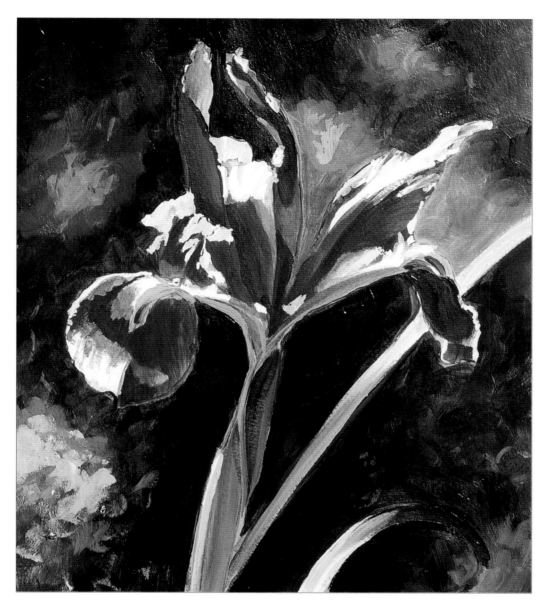

Step Six Next I add warmth and harmonize the composition by glazing a layer of phthalo green over the background. After it dries, I apply highlights to the background with cadmium yellow light and raw sienna; I also brighten the colors in the stem using these same three colors. I apply yellow and red to the interior of the petals, and I highlight the stem with a mix of yellow ochre and white. I step back and look at the overall painting to avoid overworking the details. When I'm satisfied, I stop painting and celebrate my achievement!

Painting Reflections

Incorporating a body of water into your composition will add drama and interest. Water echoes the shades and shapes surrounding it, filling it with color and dynamic forms. And the state of the water contributes greatly to the energy and mood of a painting: smooth, glasslike reflections painted with fluid strokes convey calm and quiet; choppy reflections painted with short strokes and blurred edges communicate activity. In this painting, I rendered the reflections between the extremes, balancing the serenity and solitude of a lone boat with the gentle, rhythmic rippling of the water.

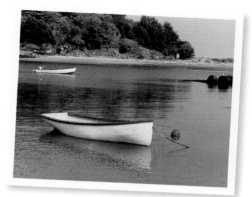

Using Artistic License Artistic license allows you to take liberties with subject matter and alter the composition or colors of a painting. Capturing the solitude of a boat in the midst of a peaceful lake was appealing to me, so I used my artistic license to remove the distant boat.

Color Palette
brilliant blue, bronze yellow, burnt sienna, cadmium red light, dioxazine purple, light blue-violet, light portrait pink, Naples yellow, Payne's gray, phthalo green, raw sienna, sap green, titanium white, and yellow ochre

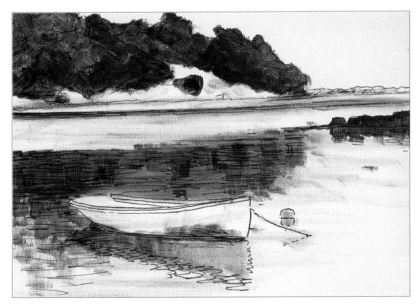

Step One I sketch the scene on the canvas using a permanent marker. (Unlike pencil, a waterproof marker will show through the first layers of paint, making it easy to follow the composition.) I limit the drawing to basic shapes. When it's complete, I block in color to establish the darkest values. Using a large flat brush, I apply thin layers of dioxazine purple, sap green, and burnt sienna. Then I simulate the reflections in the water with vertical brushstrokes, placing the darkest values within the foliage reflections and immediately beneath the boat.

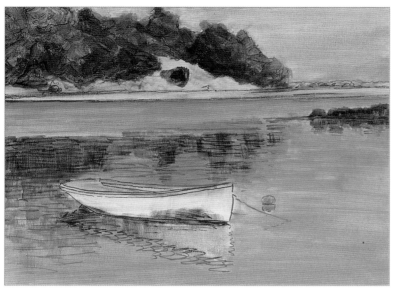

Step Two Now I add more vibrant layers of color to the canvas. For the sky, I use a mixture of light blue-violet and Payne's gray, adding brilliant blue to the mix to paint the water. Then I block in the shoreline and the trim on the boat with a mix of raw sienna and cadmium red. To build up the medium values, I add acrylic glazing medium to the paint, keeping it thin and transparent so that I can work slowly and deliberately.

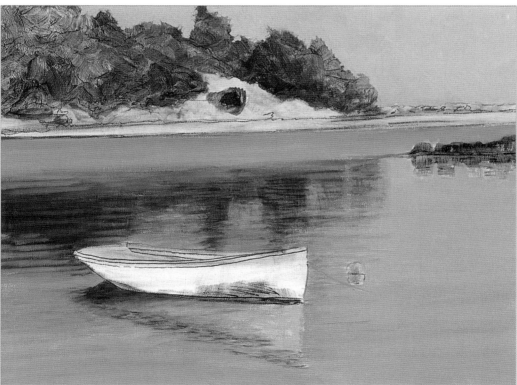

Step Three I complete the sky by applying a mix of light blue-violet, bronze yellow, and a bit of Payne's gray. I load the brush with thick paint and apply opaque strokes over the sky. As I paint, I vary the color values across the sky to add depth. Then I add another layer of color to the water, still allowing the initial dark areas of the reflections to show through. I also lightly stroke the water color over the edges of the reflection and inside to indicate subtle ripples in the water.

Step Four Working from dark to light, I build up thicker layers of darks in the trees, rocks, reflections, and boat with mixes of sap green, burnt sienna, and Payne's gray. Using a medium flat sable brush, I render the rocks on the right with a single brushstroke and a mix of burnt sienna and raw sienna. I also use this brush to paint the boat trim with burnt sienna and flesh. I drybrush reflections on the water with dioxazine purple and Payne's gray to add a choppy appearance.

Step Five Now I apply paint for the foliage and trees in the background. I add highlights to the beach and sand with a mixture of Naples yellow, light portrait pink, and titanium white. Then I add more white to this mixture to paint the boat's hull, softening the shadows with light blue-violet. I apply highlights to the rocks with raw sienna, and I apply highlights to the water reflections with mixes of light blue-violet, dioxazine purple, and white. I also add a red trim to the boat and block in the buoy with cadmium red light.

Reflection Detail I create movement in the water by blurring the edges of the reflections. I do this by breaking up the outline of the boat's reflection with short, choppy, horizontal strokes. The rougher the water, the more disjointed the reflections will appear.

Foliage Detail To create foliage, I use mixes of cadmium red light, yellow ochre, and phthalo green. I work from dark to light, applying several layers of "dabbing" strokes. I keep my strokes loose and omit the details.

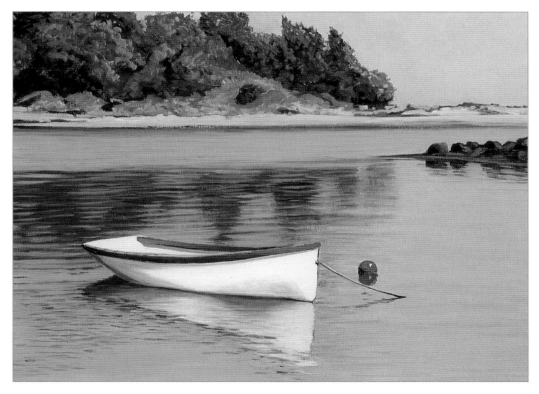

Step Six I add a few more highlights to the background and apply one more transparent glaze of light blue-violet to the water to unify the colors. I bring up the highlights on the boat with a mixture of Naples yellow and titanium white. With the thin edge of a flat brush, I add mixes of dioxazine purple, light blue-violet, flesh, and Payne's gray to the reflections with horizontal brushstrokes. I use the edge of the brush to draw the line to the buoy with a mix of dioxazine purple and cerulean blue. Finally, I highlight the top edge of the rope and the buoy with the mixture used for the boat highlights.

Glazing to Build Warmth and Texture

One of the most exciting features of acrylic paint is that you can apply it in quick-drying glazes, just as you do with watercolor. These thin layers of paint are perfect for building up colors within large areas, such as textured walls or rippling bodies of water. The grainy surface of the canvas or board "catches" the color of the glaze to give the areas a subtle variation and texture, preventing them from appearing flat and two-dimensional. In addition, glazing gives you control over the color shade; you can alter the temperature or hue slowly and deliberately, instead of immediately covering the area with one-toned, thick mixtures of paint. In this painting, I begin with cool pinks and purples; then I transform the porch into a rich, luminous scene using several layers of warm glazes. The result is a painting full of texture and mottled with color!

Color Palette
burnt sienna, cadmium red light, cadmium yellow light, cerulean blue, deep magenta, dioxazine purple, emerald green, light blue-violet, Naples yellow, Payne's gray, phthalo green, raw sienna, and titanium white

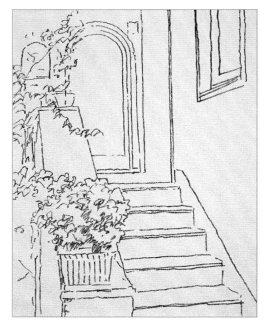

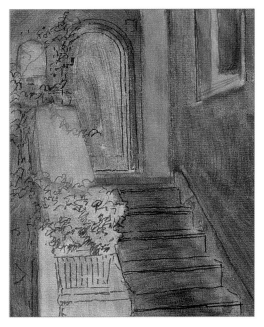

Step One Using a photo reference, I create my sketch by outlining the most important shapes on my canvas with a permanent marker. Because I will be unifying the painting with several layers of glazes, I decide there is no need for a solid underpainting.

Step Two I dip a medium flat sable brush into acrylic glazing medium and load it with paint thinned with water. I use dioxazine purple, burnt sienna, raw sienna, deep magenta, and light blue-violet to fill in each shape with color. As I work, I blend the paint hues into one another for soft edges.

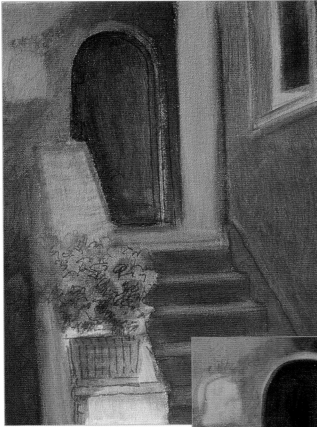

Step Three Acrylic dries quickly, so I don't have to wait long before I can begin applying glazes. I add another layer of deep magenta to the walls, some raw sienna to the flower pot, and a mixture of burnt sienna and Payne's gray to the stairwell and the window. With each successive layer, I bring out more details and intensify the color.

Step Four Now I build up the shadows by continuing to glaze with thicker paint. I concentrate on using warmer earth tones here to contrast with the cooler shades of purple. I darken and add a little definition to the doorway, adding shadows with a warm, rich burnt sienna glaze. I do the same for the bottom of the steps and the left side of the wall.

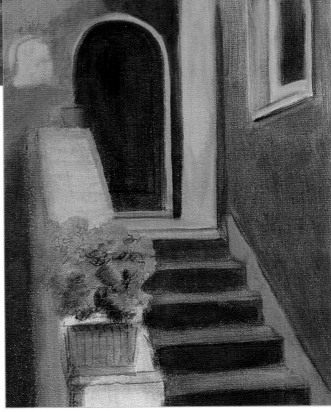

25

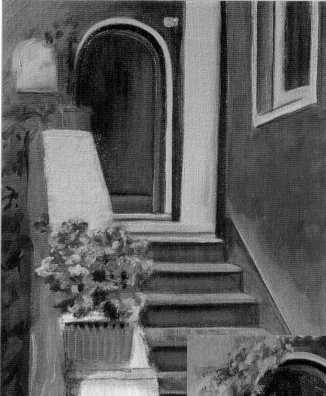

Step Five To harmonize the composition, I add a thin glaze of raw sienna mixed with cadmium red light to the wall on the right. I blend the color into the underlying layer, varying the direction of the brushstrokes for interest and texture. Then I lighten the banister and base of the wall with a mixture of light blue-violet and raw sienna. I also use this mixture to drybrush the tops of the stairs and to outline accents. Next I add color to the flowers using various mixtures of phthalo green, emerald green, cadmium red light, and Naples yellow. Then I begin to define the foliage on the left with the flat side of the brush.

Step Six With a mix of cadmium red light and raw sienna, I glaze the top of the right wall, blending down into a darker mixture of dioxazine purple, light blue-violet, and deep magenta. Next I mix a few variations of greens and blues for the foliage along the left side and apply it in quick dabs. I create several mixes to paint the flowers, using varied proportions of cadmium red light, magenta, and Naples yellow. Then I apply a layer of highlights to the walls and banister with Naples yellow, using thicker paint and adding some areas of drybrush to create a light, impressionistic feeling.

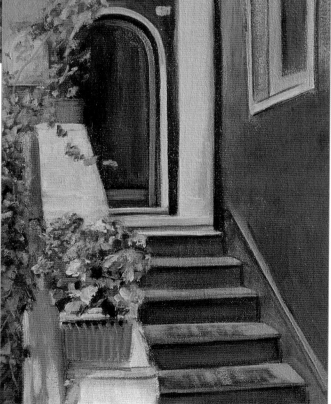

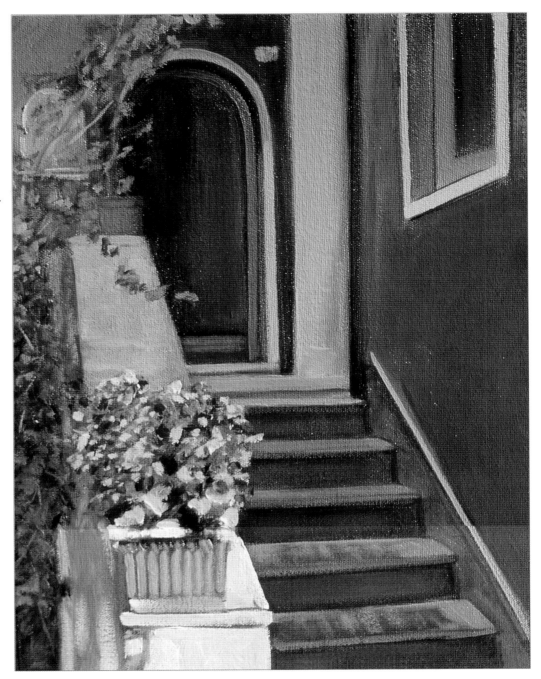

Step Seven At this stage, I apply the thickest layers of paint and the final embellishments. I sharpen the details on the doorway, window, and flower pot, and I add a dioxazine purple glaze to the upper-left corner to dull the area so that it doesn't compete with the visual focus of the flowers. Then I add the brightest highlights in the flowers with a mix of white, cadmium yellow light, and Naples yellow. A few random dabs of color complete the composition, and then I name my finished piece "Home at Last."

Working with Translucent Washes

The transparent properties of thinned acrylic paint are perfect for depicting delicate yet colorful subjects, such as reflective glass surfaces and soft flower petals. As with watercolor, you can lighten the value of an acrylic wash by adding more water to the pigment, which in turn allows more of the white support to show through the color. This gives the paint a luminous quality. You can also use acrylic washes to build up rich color in layers. Because acrylic is waterproof when dry, you can layer new washes over previous ones without lifting or changing the initial pigment. As a result, you can achieve the airy quality of watercolor with a greater degree of control over your washes.

Color Palette
burnt sienna,
cadmium yellow light,
dioxazine purple,
emerald green,
Indian red,
light blue-violet,
Payne's gray,
phthalo green,
raw sienna,
and titanium white

Step One Because I will be painting with thinned acrylic paints, I use 140-lb. watercolor paper. I draw the scene lightly with pencil so it won't show through the final washes. I am careful to outline the most important shapes and details, such as the highlights and curves within the petals.

Step Two I decide to leave some highlighted areas free of any paint so the white of the paper can serve as the highlights. I secure the paper on all sides to a drawing board with masking tape and apply liquid frisket over all future highlights so I can paint freely.

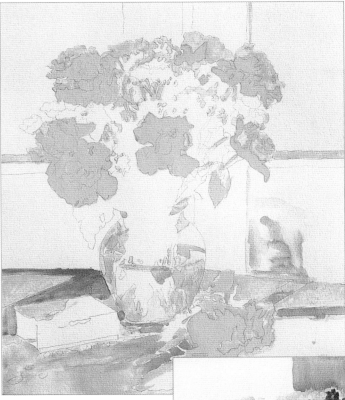

Step Three To maintain the look of watercolor, I use only water to make the paint flow, and I build up transparent layers from light to dark. I begin by applying a thin wash of color to the roses using a medium flat sable brush loaded with cadmium yellow light. After rinsing out the brush, I apply a wash of light blue-violet to the tablecloth, vase, and lower-right portion of the background.

Step Four Next I paint the dark purple areas in the flowers and vase with dioxazine purple and light blue-violet. Using a thin wash of raw sienna and burnt sienna, I define the shapes of the window frame and music box. To add depth, I apply another layer of color in the shadow areas of the tablecloth and the roses with raw sienna thinned with water.

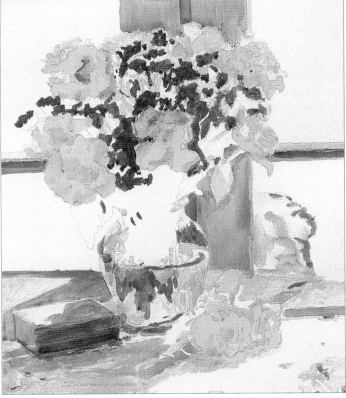

29

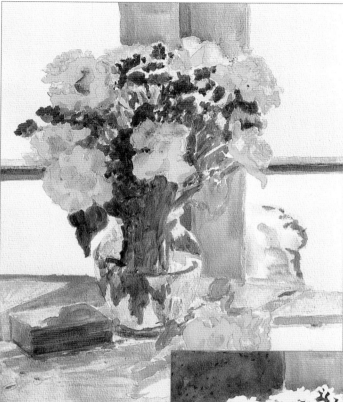

Step Five Now I introduce green to the painting. I use pure phthalo green for the stems; then I mix a bit of raw sienna and cadmium yellow light with emerald green for the leaves and the highlights in the stems. At this point, each color that I add brings a greater sense of depth and dimension to the painting.

Step Six Since the focus of this painting is the foreground objects, I am not too concerned with detail in the background. I apply purple dioxazine to the top of the background.Then I move down into a mix of emerald green and phthalo green with a touch of dioxazine purple and white, muting the colors with a little Payne's gray. I keep the paint loose and transparent for a softer effect, and I achieve a watercolor look by pulling the colors into one another while still wet. With the largest areas of color established, I let the paint dry and then remove the frisket from the highlights with rubber cement pickup. (You can also use a kneaded eraser or your finger.)

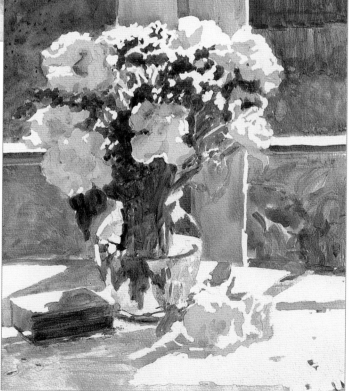

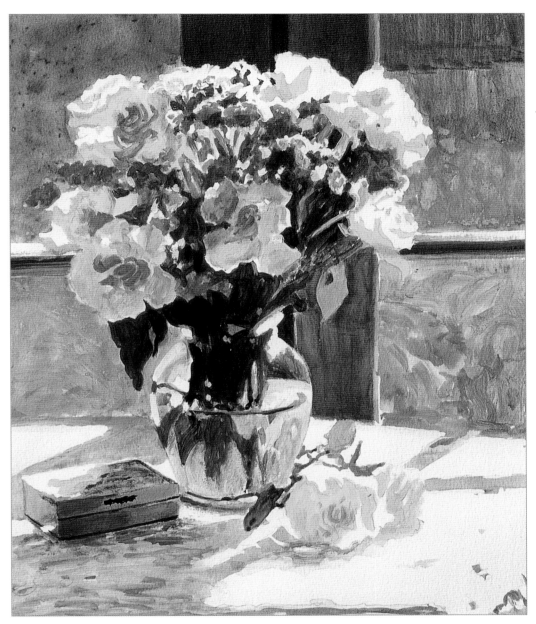

Step Seven I fill in the darkest areas of the stems using a small flat sable brush loaded with a thicker mix of Payne's gray and phthalo green, drybrushing the edges of the strokes for a soft, feathery effect. Next I darken the window frame with a layer of burnt sienna, and I add contrast to the music box and rosebuds with Indian red. I continue to darken and define a few of the petal edges using the side of the brush, and I accent a few of the highlights with a mix of cadmium yellow light and white. Then I add a few transparent layers of color to deepen the shadows, such as a wash of dioxazine purple and light blue-violet over the lower-left corner. Finally I remove the masking tape from the board and paper to view the results!

Depicting Light and Shadow

Even the simplest subject and composition can be made exciting with the addition of the intriguing play of light and shadow. For example, sunlight filtered through leaves forms a variety of fascinating shapes that engage the viewer's interest. And sometimes the patterns of light and shadow can be so compelling that *they* become the subject of the painting, rather than the physical elements of the scene. In this painting, I use a simple, linear composition of mainly horizontal and vertical lines. But, to successfully bring this quaint cottage window to life, I contrast these lines with irregular patches of sun that seem to dance off the canvas.

Color Palette
alizarin crimson, brilliant blue, burnt sienna, cadmium red light, cadmium orange, cadmium yellow light, dioxazine purple, emerald green, light blue-violet, medium magenta, Naples yellow, Payne's gray, phthalo green, raw sienna, titanium white, and yellow ochre

Step One I was inspired by the intimacy of the single-window composition, as well as the intensity of color and filter of light through the tree branches onto the cottage. Before painting, I roughly sketch the scene on canvas with permanent marker, making sure to outline each pocket of light and indicate the various types of foliage in the foreground. Then I cover the surface with a thin coat of medium magenta to provide a warm underpainting, which will ultimately give warmth to the final painting.

Step Two With a large flat brush, I establish the different values using washes thinned with acrylic glazing medium and water. I wash brilliant blue for the shutters and rooftop; then I mix alizarin crimson with a bit of Payne's gray for the side of the cottage. To block in the windows, I use dioxazine purple for the darkest areas and raw sienna for window frame definition. Then I mix phthalo green with emerald green, applying a thin wash over the foliage.

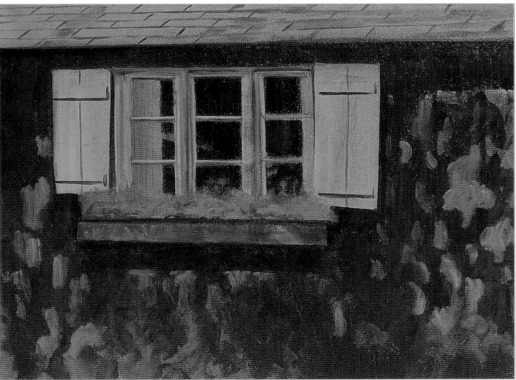

Step Three Now I block in the window interiors and outline the roof tiles using Payne's gray and a small flat brush, "drawing" with the paint. Then I add shadows to the underside of the roof, window, and flower box. I mix alizarin crimson, burnt sienna, dioxazine purple, and glazing medium to apply broad strokes of color to the walls. And I fill in some of the gaps with raw sienna, suggesting areas of light. Finally I outline the window frames with a mixture of raw sienna and light blue-violet, and I block in the flower box with a mixture of brilliant blue, dioxazine purple, and Payne's gray.

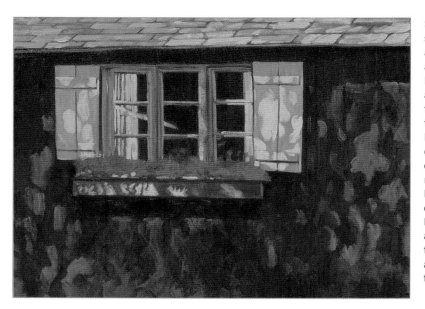

Step Four At this stage, I develop the areas of cool color and bring up some highlights. First I apply brilliant blue to the shutters, roof tiles, and window box with thick paint, drybrushing to blend one area into the next. For the brightest highlights on these objects, I apply light blue-violet. Because I am working from dark to light, I think of the areas of light as holes to be filled with color.

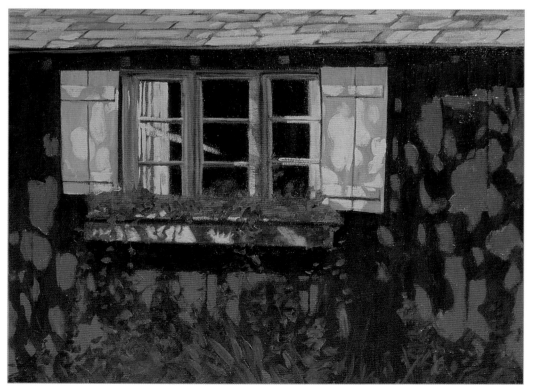

Step Five Now I apply the warm highlights on the buildings with pure cadmium red light. I use the drawing as a guide to fill in the pockets of light, and I make each spot an abstract shape by varying the size and direction of my brushstrokes. Next I load a small flat brush with a thick mix of emerald green and phthalo green and paint the foliage. For the vertical stems, I use long strokes with the edge of the brush; for the smaller leaves, I apply the paint with quick dabs.

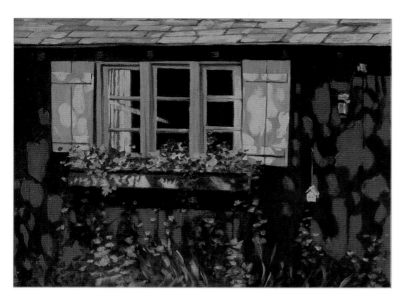

Step Six I add another layer of color to the window casing with yellow ochre mixed with Payne's gray. I apply the paint in thick, single strokes, drybrushing the edges. I brighten the foliage with medium highlights, applying a mix of yellow ochre, phthalo green, and emerald green in loose strokes. I do the same for the flowers using a mix of cadmium red light and alizarin crimson. I suggest the fuse box with cadmium red and brilliant blue, and I paint the birdhouse with Naples yellow and raw sienna.

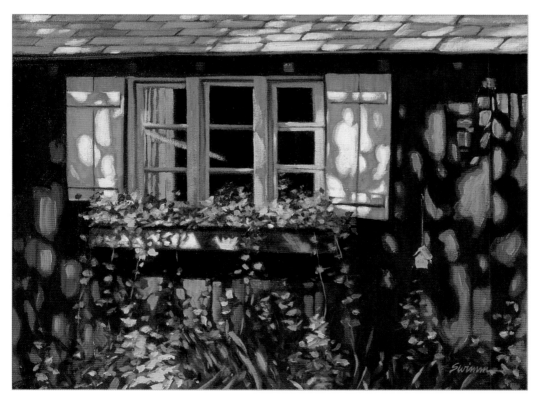

Step Seven In this final step, I apply another layer of highlights. For the roof and shutters, I use a mix of white and brilliant blue. For the side of the cottage, I use a mix of white, cadmium orange, and Naples yellow. I add some final highlights to the foliage with a mix of white, emerald green, and the yellows on my palette. I soften the edges of each stroke by drybrushing, which allows some of the warm underpainting to show through.

Setting Up a Still Life

Working from a still life setup allows you to have full control over the arrangement and lighting—and, unless you move the objects, they will always stay in the same place. When designing the *composition* (or the placement of objects within the borders of your support), arrange objects in a balanced and interesting manner. Avoid clumping the objects together in the center or to one side, and don't line up all the objects in a straight row; these setups will either stop the viewer's eye or lead it right out of the painting. Use diagonal lines instead to move the viewer's eye around the painting. In this still life, I use diagonals to guide the viewer's eye toward the focal point of the piece: the wine bottle.

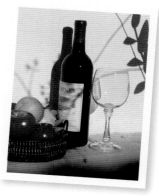

Color Palette
alizarin crimson, burnt sienna, cadmium red light, cadmium yellow light, dioxazine purple, emerald green, Naples yellow, Payne's gray, phthalo green, Prussian blue, raw sienna, titanium white, and unbleached titanium

Taking Photos You don't have to paint your still life setups from life; taking photos of your arrangement can help you frame your composition and choose the most effective angle.

Step One I sketch the scene on canvas with a permanent marker, taking care to make the shapes and perspective accurate. I use a thin wash of dioxazine purple for the underpainting, as this color complements the bright yellows I plan to add.

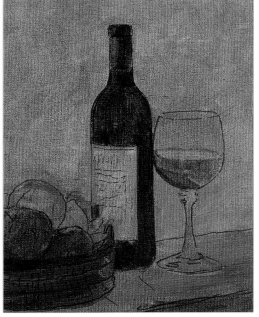

Step Two Now I define the largest shapes with layers of thin color. I use raw sienna for the background and wine label, dioxazine purple for the bottle, and alizarin crimson for the bottle's neck. I apply alizarin crimson and burnt sienna to the fruit, tabletop, and wine, and I use Payne's gray for shadows.

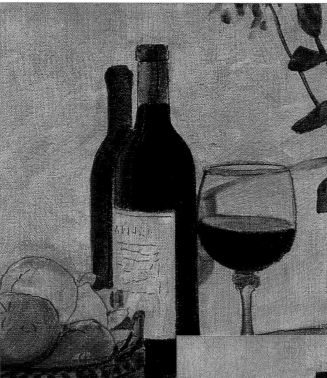

Step Three Now I paint the darkest colors of the wine bottle, glass, and shadows, using a mixture of Prussian blue and alizarin crimson. I avoid the left side of the bottle, saving this area for highlights. I also use this mix to define the details of the basket and the tabletop shadows. Then I use a mixture of burnt sienna and Payne's gray to sketch in a few reflections on the stem of the wine goblet.

Step Four At this point, I add color and dimension to the fruit. I use alizarin crimson mixed with cadmium red light to fill in the apples and outline the pear. For the highlights, I apply a mix of cadmium yellow light and raw sienna. Then I add emerald green to the mixture to paint the leaves. Next, using burnt sienna and alizarin crimson, I bring up some of the details in the neck of the wine bottle and on the label.

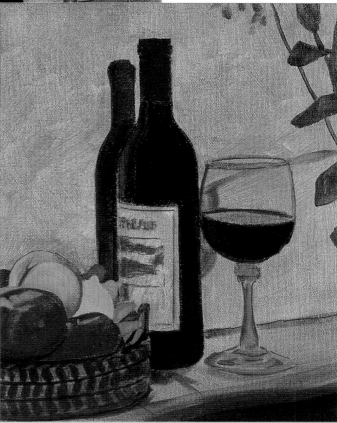

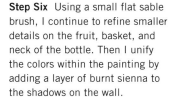

Step Five Now it's time to "light up" the composition. Mixing Naples yellow with cadmium yellow light and white, I paint the background, allowing some of the underpainting to show through for texture. I use the same mixture to highlight the wine in the glass and to add sparkle to the stem. And I also drybrush the color onto light areas of the wine label. Then I thin the mixture to make it more transparent and add the highlights on the left side of the bottle and on the glass.

Step Six Using a small flat sable brush, I continue to refine smaller details on the fruit, basket, and neck of the bottle. Then I unify the colors within the painting by adding a layer of burnt sienna to the shadows on the wall.

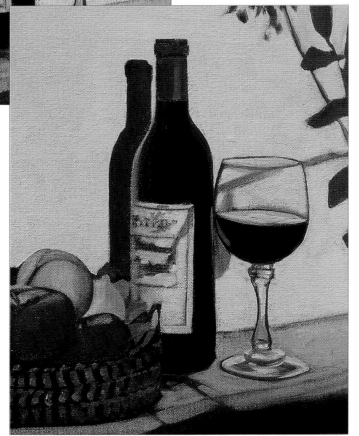

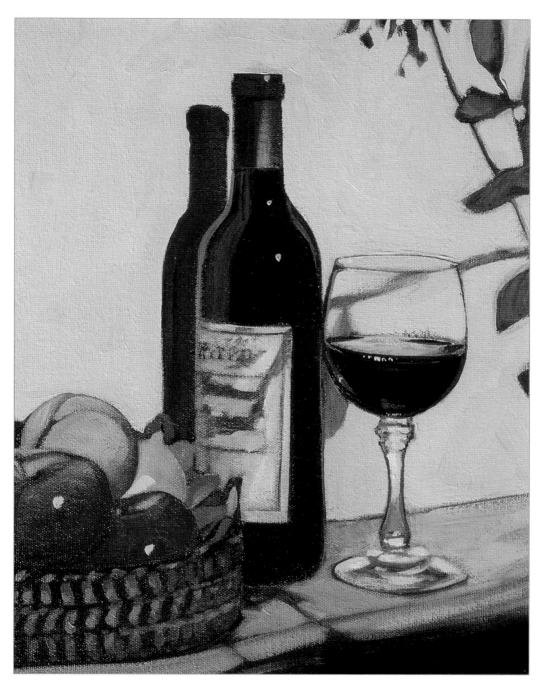

Step Seven To neutralize the background wall, I apply a thick glaze of unbleached titanium mixed with flesh and a small amount of cadmium yellow light. To create interesting textural effects, I vary the direction of the brushstrokes and paint thicknesses. Then I drybrush a few highlights onto the fruit, tabletop, and wine stem. For the highlight on the left side of the bottle, I use a mixture of phthalo green and Payne's gray. Finally I apply tiny light sparkles to the bottle, apples, and wine glass with white mixed with cadmium yellow.

Applying Linear Perspective

Employing *linear perspective* is a method of creating the illusion of three dimensions using receding lines. Because all the parallel lines of every object in a scene converge to one point in the distance, the viewer's eye is drawn in from the edges of the painting toward the center of interest. In the following scene, I use the converging lines of the side of a building and walkway to lead the eye toward the warm, interior, sunlit courtyard.

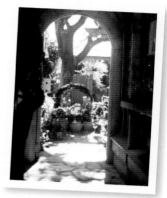

▶ **Following a Reference** I need to follow this reference closely to make sure I re-create the perspective accurately; otherwise, my painting won't be convincing. I like this photo's glowing feel and contrasts between the light and shadow, so I don't intend to make many changes to the color or composition.

Color Palette
bright orange, brilliant blue, burnt sienna, cadmium red light, cadmium yellow light, dioxazine purple, light blue-violet, Payne's gray, raw sienna, sap green, titanium white, yellow ochre, and yellow oxide

Step One I carefully sketch the scene onto my canvas with a permanent marker. The only slight adjustment I make is to show a bit more of the top of the arch.

Step Two Now I establish a "map" of the various values in the scene. Using a large flat brush, I apply thin washes of yellow ochre and dioxazine purple to the largest areas of light and dark.

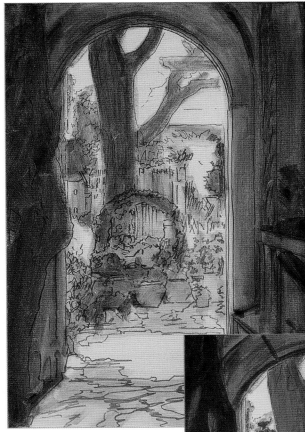

Step Three Keeping the paint thin, I fill in the arch and shadowed interior with burnt sienna. I also darken the tree trunk with dioxazine purple. I apply these washes to areas of the far courtyard as well. Then I outline the darkest areas of the foreground with the edge of a small flat sable brush and a mix of acrylic glazing medium, dioxazine purple, and Payne's gray. I also add sap green to the foliage, mixing in some Payne's gray to tone down some areas and create a little variation.

Step Four Next I strengthen the darks of the underpainting to clarify some of the shapes in the foreground. I use a mixture of Payne's gray, dioxazine purple, and burnt sienna to apply thicker layers of paint, drybrushing the edges for a soft look. Then I add a glaze of burnt sienna to the tree trunk in the courtyard. At this stage, I have a clear separation between light and shadow, as well as a good sense of the detailed areas.

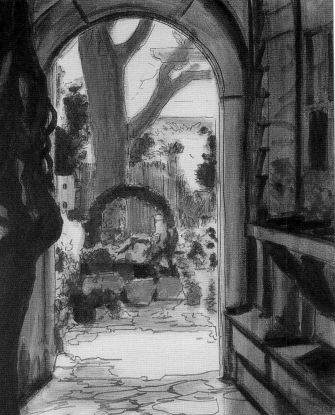

Step Five Next I create mixes of light blue-violet and brilliant blue, adding burnt sienna and Payne's gray for variation. I apply these colors to the brightest areas in the archway, softening the edges with a bit of drybrushing. To unify the background and the foreground, I apply these mixes to areas of the court-yard, such as the tree trunk and flower pot shadows. Then I start to further develop the fence, flower pots, and tiles without worrying about creating photo-perfect details— although I want the scene to look convincing, the goal for this painting is to capture the atmosphere and mood of the setting as well.

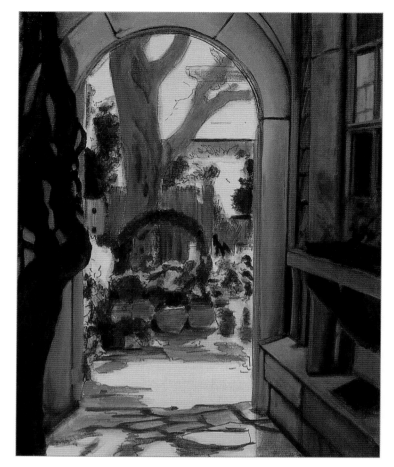

Suggesting Depth Draw a horizontal line across your picture to represent eye level, and then place a point on this horizon line for the vanishing point (VP). Next draw light lines from your subject to the vanishing point, and ensure the lines of your subject follow these guidelines.

One-Point Perspective

The illusion of three dimensions on a two-dimensional surface is called "perspective." The simplest form, called "one-point perspective," requires that you pick out one point on the horizon (called the "vanishing point") and make all the parallel lines in your painting recede to this point. This technique is important for drawing realistic scenes with a sense of depth. Employ one-point perspective when drawing street scenes, hallways, or roads that recede into the distance.

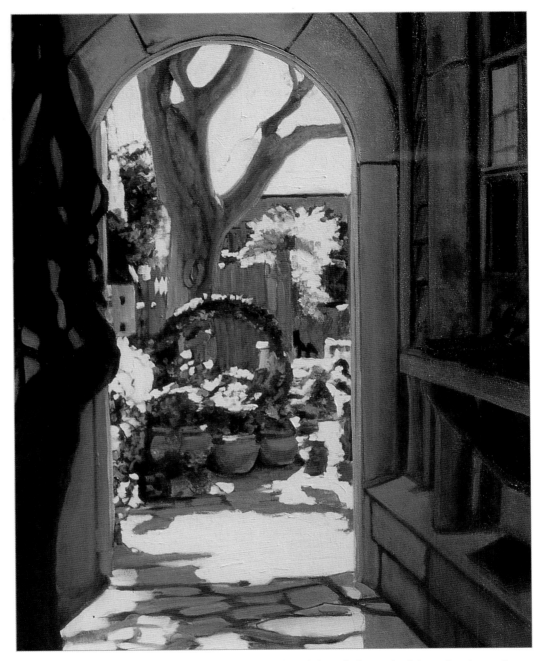

Step Six I decide that the architectural shape by the tree branch is confusing, so I paint over it and cover the sky with titanium white mixed with brilliant blue. Then I apply a mix of titanium white and yellow oxide to the sunlit areas of the courtyard. I warm up the foreground with a mix of raw sienna and acrylic glazing medium, applying a transparent layer to the arch, hallway, and floor tiles. I also mix yellow ochre and sap green to add highlights to the foliage, adding some cadmium red light for the flowers. Finally I outline the underside of the archway with a mix of cadmium yellow light, bright orange, and white.

Using Multiple References

When searching for the perfect subject to paint, don't feel as though you need to restrict yourself to copying a single source. Not only can you use artistic license to alter a scene—changing colors or subtracting unwanted elements—you can also combine elements of various references, merging multiple photos to enhance your "found" compositions. For the painting below, I taped together sections of two different photographs, each bearing aspects that I wanted to include in my landscape. Although the scene looks very realistic, it doesn't actually exist!

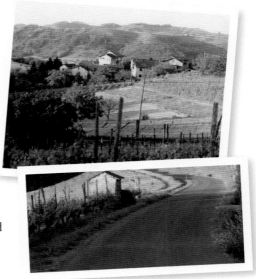

Color Palette
brilliant blue, bronze yellow, burnt sienna, cadmium orange, cadmium red light, cadmium yellow light, chromium oxide green, dioxazine purple, light blue-violet, light portrait pink, medium magenta, Payne's gray, raw sienna, sap green, unbleached titanium, and yellow ochre

Overlapping Photos To create this scene, I attached a shadowed road from one photo to the foreground of another, providing a visual path into the painting. The result is a composition with a cool and inviting path that guides the viewer to the warm, glowing fields and sunlit buildings.

Step One I begin with a rough sketch, drawing directly onto the canvas with a permanent marker. Then, with a large flat brush, I block in large areas of the base colors, using medium magenta for the sky, dioxazine purple for the hills and the foreground, and raw sienna for the buildings and the areas that are in direct sunlight. I mix in water and acrylic gloss medium to get the paint to flow thinly and loosely.

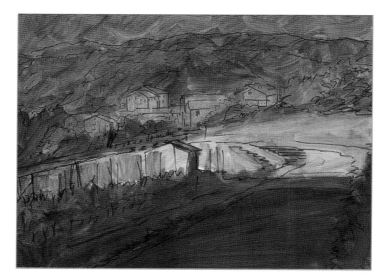

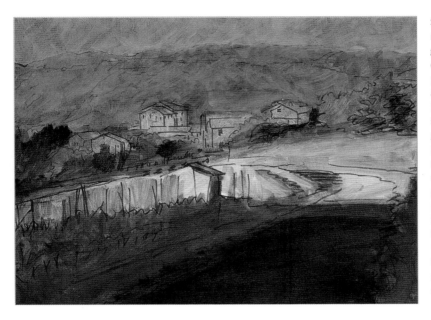

Step Two Next I mix my paints with acrylic glazing medium to create more transparent colors. I apply a thin layer of light blue-violet to the sky and a mix of sap green and brilliant blue to the hills. I add various mixes of chromium oxide green, sap green, and Payne's gray to the trees and the foreground. I strengthen the shadows with a mix of Payne's gray and dioxazine purple.

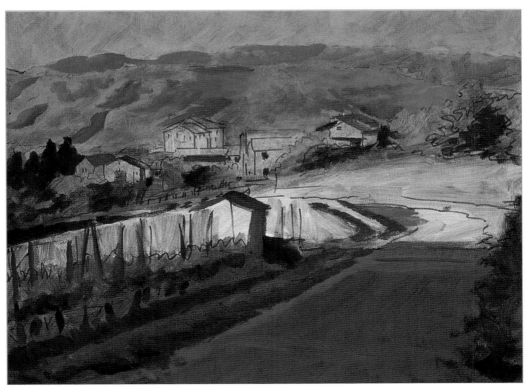

Step Three Now I mix acrylic gel extender with the paint for thicker, more opaque colors. I let my initial sketch guide me as I block in distant shadows with a medium flat brush and a mix of sap green and dioxazine purple. Then I use Payne's gray mixed with sap green for trees and foreground shadows. Finally I add another layer of more opaque color to the road and shadows using a mix of Payne's gray and brilliant blue.

Step Four I apply highlights using bronze yellow mixed with light blue-violet for the left side of the hills, switching to brilliant blue mixed with chromium oxide green for reflected light in the shadows. I also add touches of burnt sienna and raw sienna to the rooftops and light blue-violet and brilliant blue to the shadows. In the foreground, I mix raw sienna and light blue-violet with Payne's gray for the shack, and I use sap green, Payne's gray, and light blue-violet for the vines at left and the tree on the right.

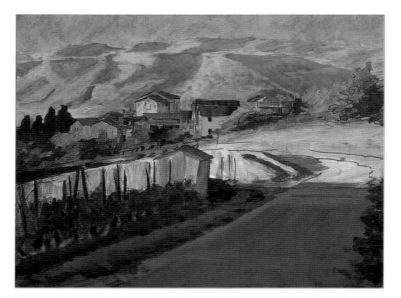

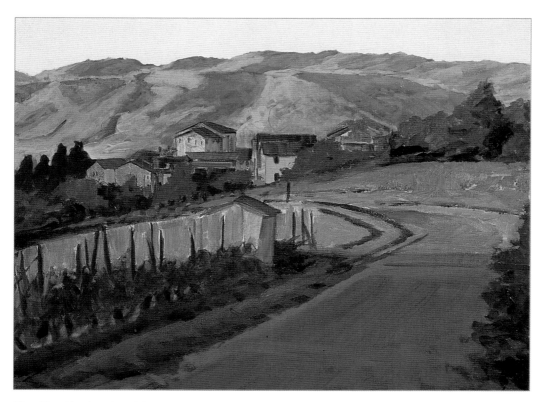

Step Five Now I apply a thick, opaque mix of light portrait pink, light blue-violet, and unbleached titanium to the sky, varying the direction of the brushstrokes to create texture. Next I mix cadmium red light, sap green, and raw sienna to block in the middle values of the trees, adding a little dioxazine purple to separate the shadows. Then I add color to the sunlit areas with a mix of bronze yellow, yellow ochre, and sap green.

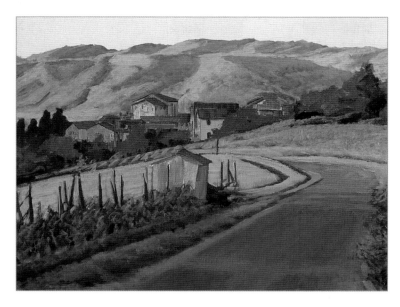

Step Six To add more warmth to the painting, I start with a mix of medium magenta and bronze yellow, applying the brightest highlights to the background hills. For harmony and balance, I add medium magenta to the sunlit field, this time mixed with yellow ochre and cadmium orange. Then I brush on a medium magenta glaze over the foreground shadows. I also detail the vines and foliage by drybrushing layers of light blue-violet mixed with chromium oxide green.

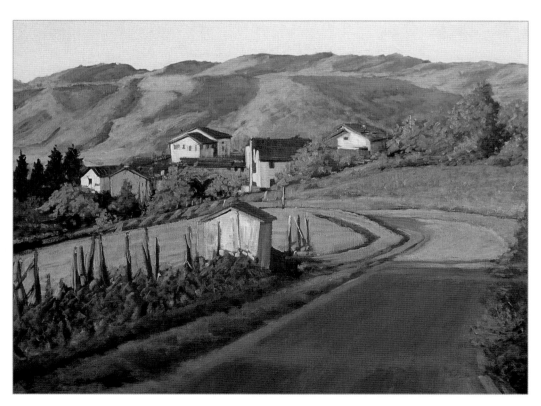

Step Seven To apply highlights to the buildings, I use the same mix that I created for the sky, but I switch to a medium flat sable brush—perfect for "drawing" and creating sharp, crisp edges. Then I bring up the details in the foreground, adding highlights to the trees with a mix of cadmium yellow light, cadmium orange, and sap green. Finally I brighten some of the foreground shadows with light blue-violet and dioxazine purple.

Choosing a Viewpoint

One way to add drama to a landscape is to view the scene from an interesting angle that highlights the focal point. Where you place the horizon line (the line at which the sky meets the land) determines the area of the painting that will attract the most attention. A low horizon brings focus to the sky, but a high horizon draws the eye to the foreground. The viewpoint doesn't need to be extreme to be effective; even a slightly high or low viewpoint can focus on shapes and features you wouldn't notice at eye level. The slightly elevated viewpoint in this high-horizon painting brings the viewer's eye from the foamy foreground to the buildings, where crisp edges and a compelling play of light and shadow serve as the focal point of the painting.

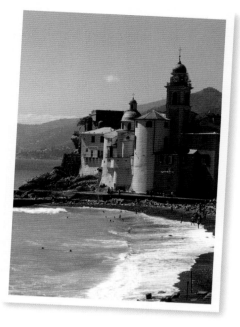

Taking an Elevated Viewpoint I took this photo from a location higher than the ocean and beach, which elongated the foreground area to include a winding shoreline that entices the viewer into the painting.

Color Palette
brilliant blue, burnt sienna, cadmium red light, dioxazine purple, light blue, light blue-violet, light portrait pink, Payne's gray, phthalo green, Prussian blue, raw sienna, sap green, titanium white, yellow ochre, and yellow oxide

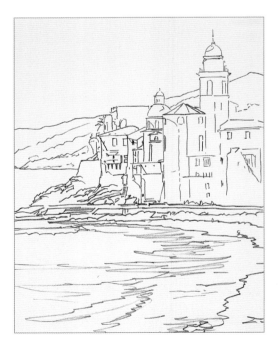

Step One First I make sure my drawing is accurate in perspective and proportion. Then I enlarge it and project the image onto my canvas, where I trace it with a permanent marker. I also indicate the shapes that define the separations of light and shadow.

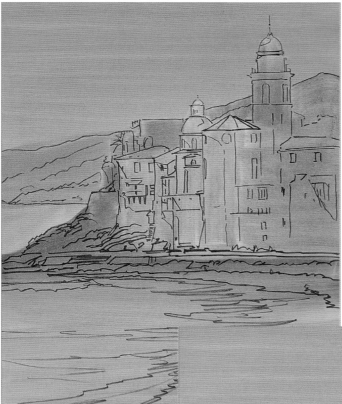

Step Two Next I break up the components into their basic colors and values. Using a large flat brush, I thin the paint with water to keep it free-flowing and transparent. For the sky, hills, and water, I apply brilliant blue; for the shadows and foreground, I use dioxazine purple; and for the sunlit areas of the buildings, I stroke on yellow oxide. I also add dioxazine purple to the hills and water.

Step Three Now I apply a layer of intense color to the scene to further define the value differences and establish depth. I mix a bit of acrylic glazing medium with the paint to make it flow easily. Beginning with the hills in the background, I apply mixes of Prussian blue, Payne's gray, brilliant blue, and phthalo green. For the light portions of the buildings, I apply raw sienna, using yellow ochre for the highlights. Then I apply phthalo green mixed with Prussian blue to the water, using lighter shades as I move down. For the building shadows, rocks, and beach, I use a mix of dioxazine purple and burnt sienna.

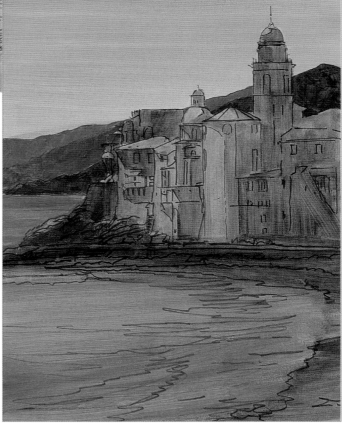

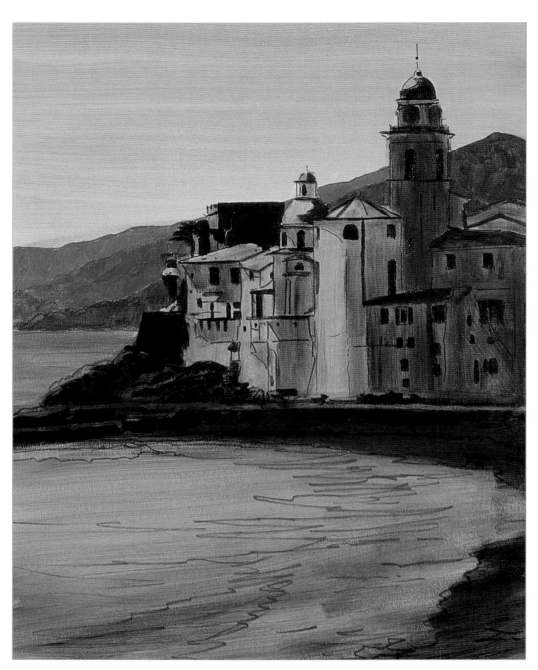

Step Four At this point, I block in the darkest colors of the buildings and the waterfront with a medium flat sable brush, which allows me to "draw" the details with crisp, controlled edges. I load the brush with a thick mix of Payne's gray and dioxazine purple, filling in the shadows and architectural details, such as the windows and clock towers. Then I use the same purple-gray mix to cover the rocks and beach. When this layer dries, I glaze the shadows with burnt sienna mixed with dioxazine purple.

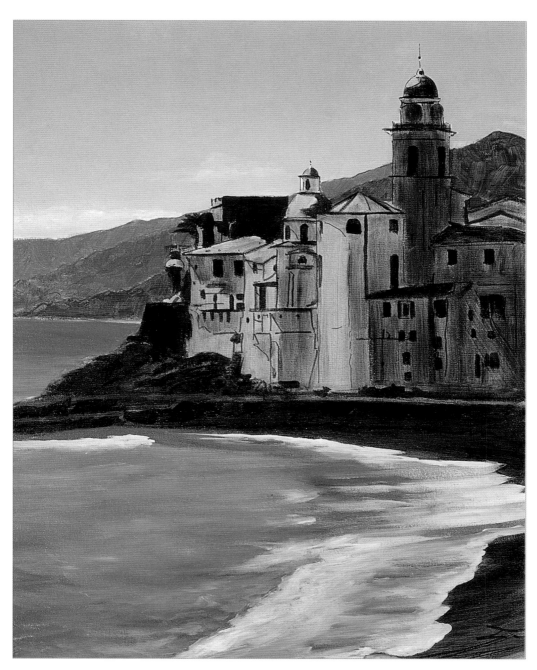

Step Five I paint the sky in one step, keeping the paint wet so that I can blend and gradate the colors. Working from dark to light, I start at the top with a mix of titanium white, light blue-violet, and light portrait pink. As I move down, I work in more white and pink. I paint the water with a darker blue mix using varying stokes to shape the wavy surface. For the breaking surf, I load the brush with white and light portrait pink and pull the color from right to left. After the paint dries a bit, I drybrush the edges to soften them. For the buildings' reflections, I add a bit of raw sienna to the water.

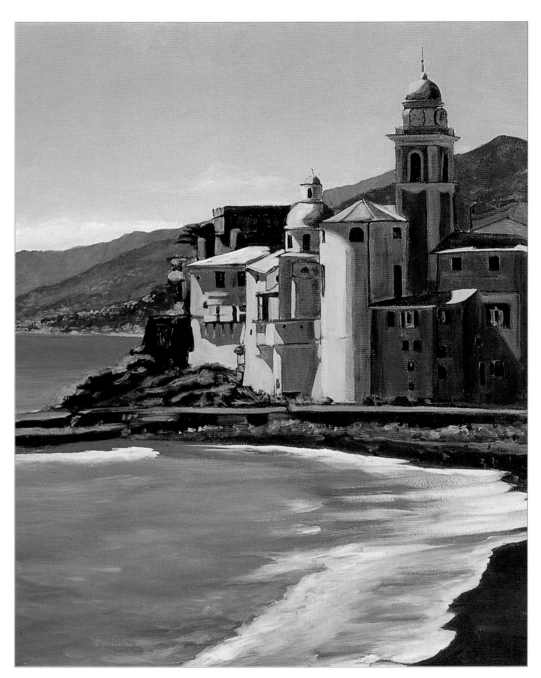

Step Six Next I mix sap green with brilliant blue and paint the hills with random, drybrush strokes. Then I use the same technique with light-blue violet, raw sienna, and a bit of white to suggest buildings in the background. Next I mix light blue-violet, cadmium red, and raw sienna for the rocks and parts of the buildings, using the edge of the brush to define them with simple blocks of color. I also use a gray mix to separate some of the details in the clock tower. With a mix of yellow oxide and white, I add another layer of color to the highlighted areas; then I further brighten the rooftops with pure white. Finally, with mixes of brilliant blue, light blue-violet, and white, I add details to the windows, clock tower, and shoreline.

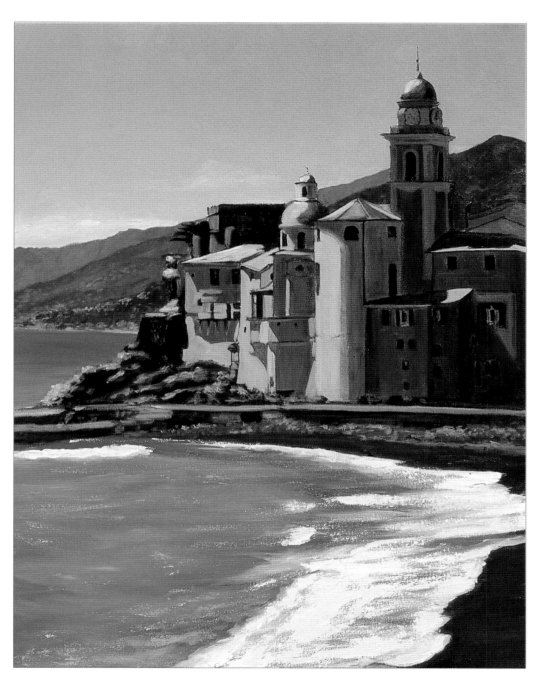

Step Seven Now I mix raw sienna with acrylic glazing medium and apply a thin layer of color to the buildings' shadows and the shoreline, also adding highlights to the rocks and the walkway using raw sienna mixed with light blue. To create the final highlights in the white surf and the blue water, I load the edge of my palette knife with white and light portrait pink and pull the color across the canvas. I also add a little raw sienna to the water for the building reflections. I make sure to not get carried away with any more detail—remember that when you step back from the painting, your eyes will fill in the details for you!

Simplifying a Scene

Landscapes and street scenes can be challenging subjects for beginners because they often involve many elements and details, such as people, buildings, greenery, and walkways. To make these subjects more approachable, apply some basic rules of simplification. Decide what you want the focus of the painting to be, and choose just a few other elements of interest. Don't try to duplicate everything you see in a photo reference, as too many elements will make the painting busy and divert the viewer from your focal point. Here I simplify the image of a Mediterranean café by removing a number of distracting elements.

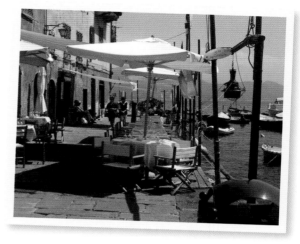

Eliminating Elements My goal in simplifying this photograph is to establish a clean path for the eye, toward the charming sunlit umbrellas. To unclutter the scene, I remove the vertical posts on the right, as well as the trash can and the foreground shadow.

Color Palette
brilliant blue, burnt sienna, cadmium red light, cadmium yellow light, dioxazine purple, light blue-violet, light portrait pink, medium magenta, Payne's gray, Prussian blue, raw sienna, titanium white, and yellow ochre

Step One I use a permanent marker to make a rough sketch of my simplified café directly on the canvas. Then I cover the canvas with a thin underpainting of medium magenta, making sure that the sketch is still visible beneath.

Step Two Now I apply thin washes of preliminary colors to help separate and simplify the visual elements. Using a large flat brush and paint thinned with water and acrylic gel medium, I apply the paint with quick strokes. For the sky, hills, water, and shadows, I use brilliant blue, Prussian blue, and dioxazine purple. For the warm light on the buildings, umbrellas, and walkway, I apply raw sienna.

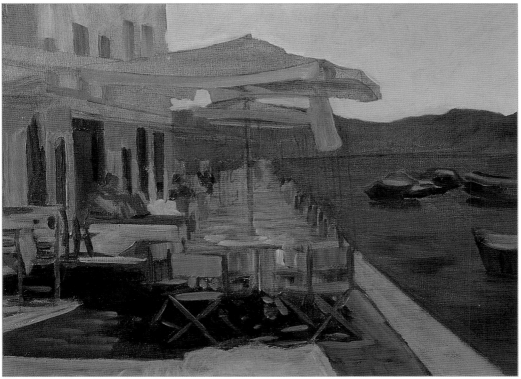

Step Three I create more contrast in the values and continue breaking down the composition into basic shapes. I thicken the paint with opaque acrylic gel to intensify the underpainting colors. I apply a deep mixture of dioxazine purple, Payne's gray, light blue-violet, and raw sienna to the shadowed areas and light blue-violet to the sky. I mix Prussian blue with brilliant blue and dioxazine purple, adding it to the sky and water. I also add a thin glaze of cadmium red light and cadmium yellow light to the buildings, tables, and sidewalk. I begin to add some rough details in the chairs, tables, and boats with strokes of Payne's gray, light blue-violet, and burnt sienna. Then I block in an underpainting for the reflected light using a mix of Payne's gray, light blue-violet, and raw sienna.

Step Four I apply a thin layer of raw sienna, cadmium yellow light, and acrylic glazing medium to the highlighted areas. Next I apply a mix of light blue-violet and Payne's gray to the sky, blending in subtle highlights of light portrait pink in the clouds. I add a lighter value of the previous blue mix to the hills and apply mid-range tones to the water with thin, loose strokes, pulling some paint away to reveal some underpainting. I add definition to the buildings with cadmium red light, cadmium yellow light, and light blue-violet, and I apply a mix of Payne's gray and brilliant blue to the windows.

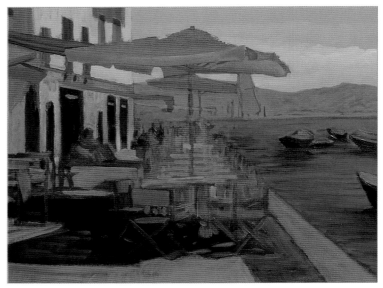

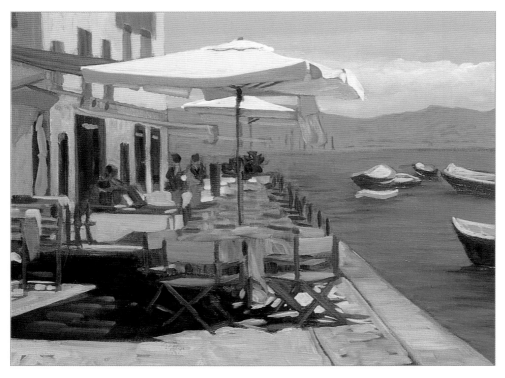

Step Five Next I mix cadmium yellow light with titanium white and apply a thick layer to the umbrella tops and boat highlights, further enhancing the contrast between light and shadow. I add a touch of Payne's gray to the mixture to bring up the highlights on the sidewalk. I also apply more detail to the chairs, tabletop, and umbrella shadows, working loosely and adjusting the colors along the way, always maintaining a feeling of spontaneity.

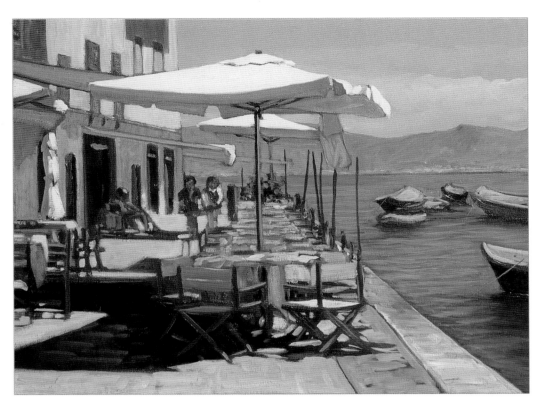

Step Six At this point, I decide that "less is more"—I'm careful not to focus too much on small details; instead I keep my brushstrokes bold and confident. I add some highlights to the hills and water with mixes of light blue-violet, light portrait pink, yellow ochre, and brilliant blue using the edge of a flat brush, blending the color by drybrushing. Using the same technique, I add highlights to the figures, tables, and chairs. I paint the final highlights on the umbrellas with a mix of light portrait pink and white, and I finish the painting by applying a thin layer of yellow ochre to the sidewalk.

Table Detail When encountering a busy area of a painting, I keep my brushstrokes unrefined and don't worry about painstakingly rendering each item. To suggest the napkins, plates, and glasses on the table, I apply various mixes of white, brilliant blue, light blue-violet, cadmium red, and cadmium yellow light with loose, impressionistic strokes and dashes.

Creating Depth

There are a few tricks to creating the illusion of depth on a one-dimensional canvas. In addition to following the rules of linear perspective (see page 40), you can also apply *atmospheric perspective* to successfully suggest three-dimensional space. This principle refers to the fact that objects in the distance appear less distinct and bluer in color than nearer objects do; this is because particles (such as moisture and dust) in the air block out certain wavelengths of light. As a result, objects in the foreground appear brighter in color and have more detail, whereas objects farther away are more muted and less detailed. When you apply this basic principle to your painting, you can effectively achieve the impression of distance, as I do in this painting of Lake Como in northern Italy.

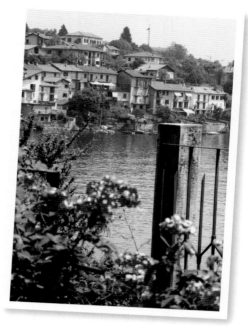

▶ **Choosing a Photo** For a painting that shows a lot of depth and dimension, it's important to work with good references. Take photos that include elements in the foreground (like flowers or fence posts) to bring distant objects into perspective.

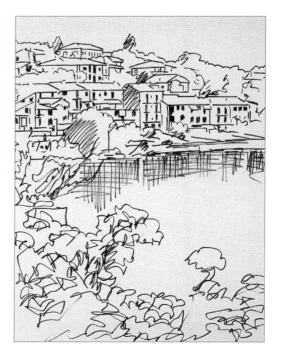

Color Palette
alizarin crimson, brilliant blue, burnt sienna, cadmium orange, cadmium red light, cadmium yellow light, dioxazine purple, emerald green, light blue, light blue-violet, light portrait pink, Naples yellow, Payne's gray, phthalo violet, Prussian blue, raw sienna, sap green, titanium white, unbleached titanium, and yellow ochre

Step One I sketch the scene on the canvas with a thin permanent marker, drawing only enough detail to establish the basic shapes of the buildings and surrounding foliage. I do the same with the foreground, and then I indicate the dark values in the water with several quick, overlapping strokes.

Step Two I begin painting by washing a thin coat of dioxazine purple over the sketch, allowing the paint to dry completely. Next I block in the sky with a mix of brilliant blue and light blue-violet. Then I blend a bit of Payne's gray into this mixture and apply it to the water. For the reflections in the water, I add Prussian blue and sap green to the mix, along with a bit of acrylic gloss medium for transparency. I apply this mix to the water with vertical brushstrokes of varying lengths.

Step Three Now I block in the cool base for the foliage, adding the darkest colors first. I use mixes of brilliant blue, light blue-violet, Payne's gray, Prussian blue, and sap green. I also take care to paint around the clusters of pink flowers in the foreground foliage.

59

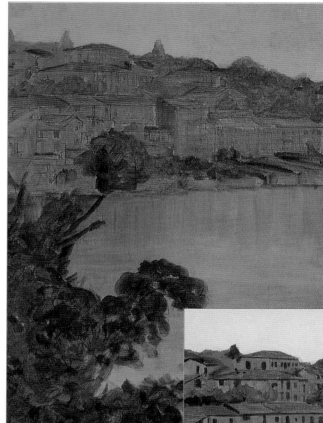

Step Four Next I use burnt sienna mixed with raw sienna to block in the rooftops. Then I apply alizarin crimson to the flowers in the foreground, and I paint a layer of light blue-violet mixed with Payne's gray over the buildings to give them shape. I make my brushstrokes loose and spontaneous to keep from overworking the painting. At this point, I can already detect a sense of depth and atmosphere!

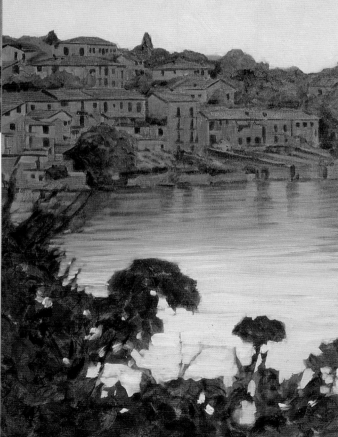

Step Five I begin to build up the forms of the buildings. Then I darken the water closest to shore with the same shades used in step two, gradually pulling down the color by drybrushing. To add more color and definition to the foliage, I apply a mix of sap green and emerald green. I also brighten the values in the sky and water with a mix of white, light portrait pink, and light blue, thickened with acrylic gel medium. Then I add another layer of color to the buildings with variations of brilliant blue, light blue-violet, and dioxazine purple.

Flower Detail 1 I begin painting the flower clusters with an uneven layer of alizarin crimson over the dioxazine purple underpainting. Then I paint the water around the flower cluster; I am not afraid to lose the edges of the flower, as I will re-establish the petals later with opaque strokes.

Flower Detail 2 Next I mix variations of phthalo violet, cadmium red light, cadmium yellow light, and white, applying the paint with thick, opaque strokes. I finish the cluster by adding warm highlights with a few strokes of white mixed with cadmium yellow light.

Building Detail To establish the dark areas of the buildings, such as the windows and doors, I use the edge of a medium flat sable brush loaded with Payne's gray to "draw" the details. In this preliminary step, I also create a soft lavender base for the buildings by creating several mixes of the blues and purples on my palette (using various proportions of brilliant blue, light blue-violet, phthalo violet, and Prussian blue). I apply the paint with vertical strokes, drybrushing for variation so that the areas don't appear flat. These cool lavender strokes will serve as the shadowed areas of the building, contrasting with the warm tones of the foreground flowers and pushing back the buildings to suggest distance.

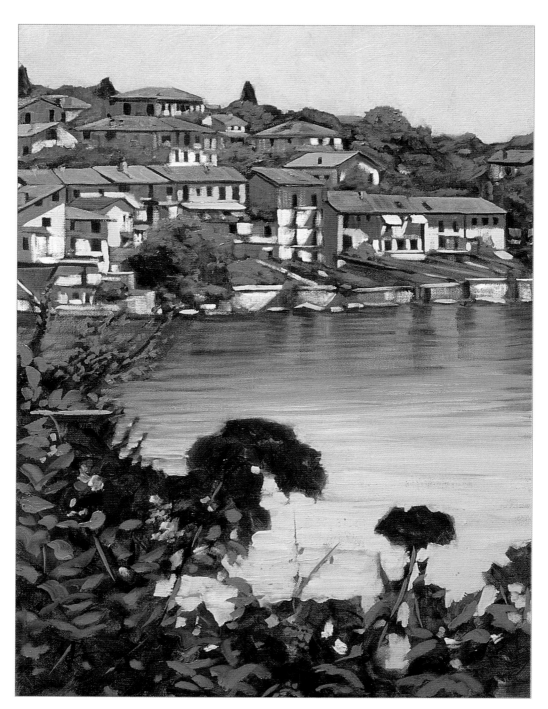

Step Six To balance the rooftops with the lightness of the sky, I add brighter values. I mix several variations of white, unbleached titanium, cadmium orange, cadmium red light, and cadmium yellow light. For the areas that are in direct sunlight, I stroke on a mixture of white and Naples yellow. Then I apply these variations to the rooftops with thick strokes, keeping each roof distinct from its neighbor's.

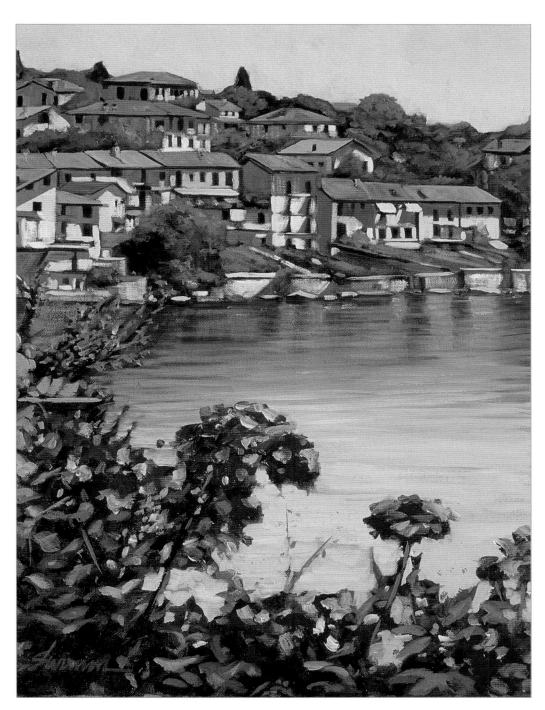

Step Seven Now I add a few final details to the buildings to strengthen the contrast of light and shadow. I bring up the highlights in the foliage with a light green mixed from cadmium yellow light and yellow ochre. Then I add bold strokes of color to the foreground flowers with the mixes of alizarin crimson, cadmium red light, phthalo violet, cadmium orange, light portrait pink, and white already on my palette. Finally I add a few dabs of a pink mix of light portrait pink and cadmium orange to the water to unify the colors.

Conclusion

Throughout this book, I've introduced you to a number of subjects, painting techniques, and approaches for working with acrylic. Now that you have experimented with them all, take what works best for you and continue to cultivate your newfound skills as you develop your own personal style. And remember that there are always new things to discover about acrylic, so don't be afraid to experiment. Take on new challenges and test out techniques—you never know what imagination and practice will produce!

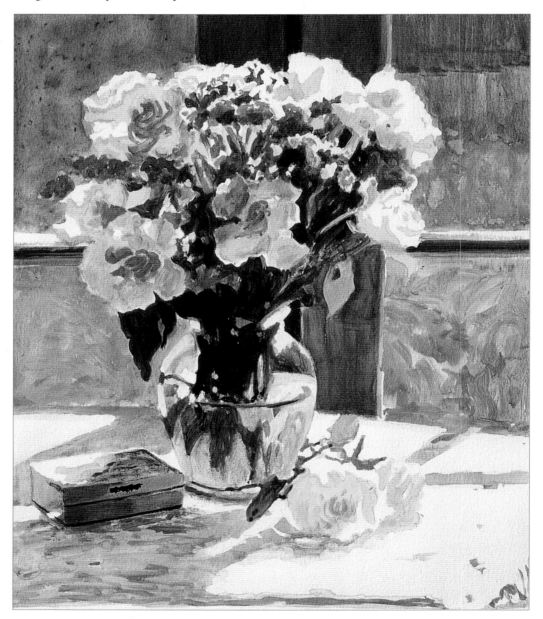